W9-ASQ-655

For the wolves who
allowed me on
the journey. R.S.

Acknowledgments

I want to thank the following people for help with this book: Sue Behrns, Curtis J. Carley, Gary Henry, John Houk, Chris Lucash, Warren Parker, Dorothy Patent, Michael Phillips, Will Waddell, and as always, my wife, Marie Smith.

PHOTOGRAPH CREDITS

Curtis J. Carley, pages 16, 21; William Muñoz, *iv*, 5, 20, 22, 29 bottom, 49; Mike Philips, U.S.F.W.S., 15, 41, 50; John Taylor, U.S.F.W.S., 35; U.S. Fish and Wildlife Service, 37, 92, 94; Mel Woods, 6, 9. All other photographs are by the author.

Library of Congress Cataloging-in-Publication Data

Smith, Roland, date
 Journey of the red wolf / Roland Smith ; photographs by the author.
 p. cm.
 Includes index.
 ISBN 0-525-65162-4
 1. Red wolf—Southern States—Juvenile literature. 2. Wildlife reintroduction—Southern States—Juvenile literature. [1. Red wolf. 2. Wolves. 3. Endangered species. 4. Wildlife reintroduction.] I. Title.
 QL 737.C22S64 1996
 599.74′442—dc20 95-10641 CIP AC

Published in the United States by Cobblehill Books,
an affiliate of Dutton Children's Books,
a division of Penguin Books USA Inc.,
375 Hudson Street, New York, New York 10014

Designed by Charlotte Staub Printed in Hong Kong First Edition
10 9 8 7 6 5 4 3 2 1

Contents

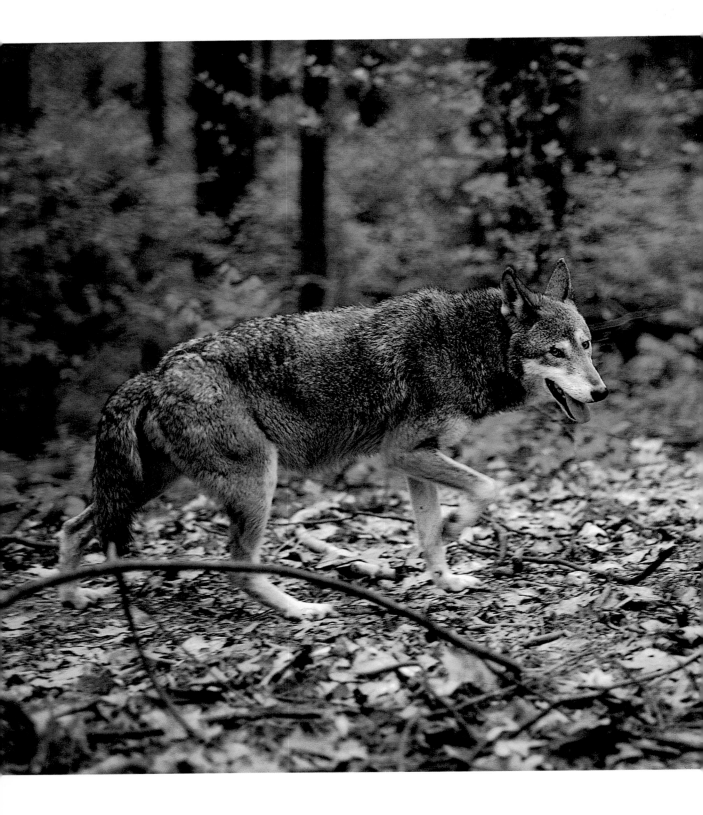

Author's Note

One hundred and fifty years ago the wolf was found in great numbers throughout North America. It was then common for people to see wolves loping over the Great Plains, dashing through vast forests, or vanishing into the thick vegetation growing along rivers. Captain Meriwether Lewis, of the Lewis and Clark Expedition, wrote that the wolves prowling around the edges of the immense buffalo herds were so common that they reminded him of the sheep dogs he'd seen in West Virginia herding domestic livestock.

In the 1800s the red wolf was found throughout the southeastern United States, but by mid-1960 the species was nearly extinct, with only a few wolves remaining in Texas and Louisiana. For their own protection, these animals were taken into captivity. By 1980 the red wolf was no longer found in the wild.

This is the story of the red wolf's remarkable journey from the brink of extinction, to captivity, and back to the wild.

For many years, I had the good fortune to work closely with the red wolf and the people trying to save it. As Red Wolf Species Coordinator for the American Zoo & Aquarium Association I helped set up red wolf breeding programs in zoos all over the United States. I traveled throughout the

Southeast inspecting reintroduction sites and training biologists in the proper care and handling of red wolves. I also assisted in tracking and trapping reintroduced red wolves in the wild.

The years I spent with the red wolf project were truly wonderful. It was very heartening to see people from all walks of life working together for a common cause. I want to thank all of those whom I met on this journey for giving their time, talents, and thoughts to the recovery of this little-known wolf.

As I wrote this book, I tried to see both through the eyes of the red wolf and through the eyes of the people who met the wolf on its journey. These imagined scenes are based on fact.

A portion of the proceeds of this book is being donated to "The Red Wolf Fund" sponsored by the Tacoma Zoological Society. This fund is being used exclusively to help save the red wolf from extinction.

If you are interested in further information about the red wolf, or want to know how you can help in its recovery, please write to: The Red Wolf, Point Defiance Zoo & Aquarium, 5400 North Pearl Street, Tacoma, Washington 98407.

chapter 1

The End of the Road

East Texas, 1961

Two men stand concealed in a small grove of trees. Both wear heavy clothes to protect them from the early morning chill and both hold rifles with high-powered scopes.

One of the men reaches for the rabbit call hanging around his neck. He glances at his partner and his partner nods. A sharp squeal shatters the silent morning.

A male red wolf bedded down for the day hears the high-pitched cry. He sits up and cocks his sensitive ears toward the sound. The cry is nearby—it comes again, sounding like the distress call of an injured rabbit. An easy meal. The wolf has not eaten in two days. He begins to move toward the sound, then stops.

It's daytime—the dangerous time when men come to the swamp where the wolf lives. They come on foot, on horseback, riding noisy machines, leaving their smell wherever they pass. They bury steel jaws on the paths and sprinkle scent that is hard to resist. They chase him and fire guns. During the other seasons the daytime is safer. The heat and insects keep the men away. But it is the cold time now and every night as the wolf searches for food he smells the scent of men.

The sound comes again. The wolf is nervous, but hunger pushes him toward the cry.

The man with the call spots the wolf first. He touches his partner on the shoulder and points.

"It's big," one man whispers.

"Too far away, though," the other man says.

"Should I give another call?"

"I don't know. It looks spooked. The call might scare it away."

"We'll give it a little time then."

Cautiously, the red wolf advances farther into the clearing. He stops in the open and concentrates all his keen senses on his surroundings.

"Give it another blow," the man whispers. "Not too loud—it's still too far away. I'll keep my scope on it. If he bolts, I'll try to put one in him."

A squeal comes from the trees across the clearing. The wolf knows instantly that something is wrong—the sound is not rabbit. He turns to run, but before taking a step he is knocked off his feet and a searing pain spreads through his body.

"I got it good," one man shouts. "It won't get far." He fixes the wolf in the cross hairs of his scope and squeezes off another round.

"That's it for him," the other man says. "I wonder how many we'll be able to call in today?"

Wolves and Coyotes

Wolves and coyotes belong to the family Canidae (kay-na-dee). The word *Canidae* is Latin, meaning "doglike" or "in the shape of a dog." The three largest wild canines found in North America are the gray wolf, the red wolf, and the coyote. Of the three, the gray wolf is the biggest, weighing 50 to 120 pounds. Next in size is the red wolf at 45 to 80 pounds. The smallest of the three is the coyote, weighing 14 to 35 pounds.

The most common wild canine in North America is the coyote. Hundreds of thousands of coyotes live throughout the United States and Canada.

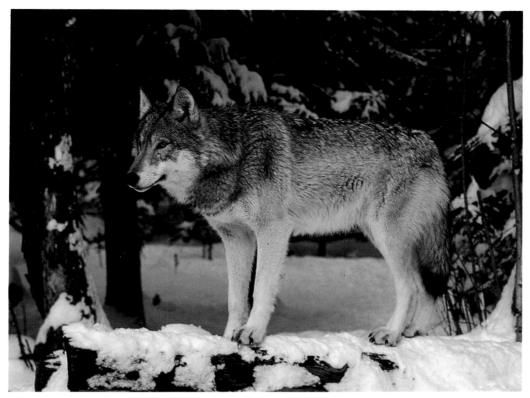

The red wolf is slightly smaller than its close relative, the gray wolf, pictured here.

The gray wolf, which once roamed through most of the lower forty-eight states, now lives mainly in the wilderness areas of Canada, Alaska, with small populations (less than 2,000 total) in Minnesota, Michigan, Wisconsin, Washington, Idaho, and Montana.

The rarest wild canine in the United States is the red wolf with a population of less than 300—most of which are in captivity. It was once found from central Texas to Florida. The red wolf is a slender animal with long legs. Its name comes from its beautiful cinnamon-colored hair.

Red Wolf Origins

There are still questions about whether the red wolf is a true species or not. Some scientists think the red wolf has lived in the southeastern United States for hundreds of thousands of years, long before the gray wolf was

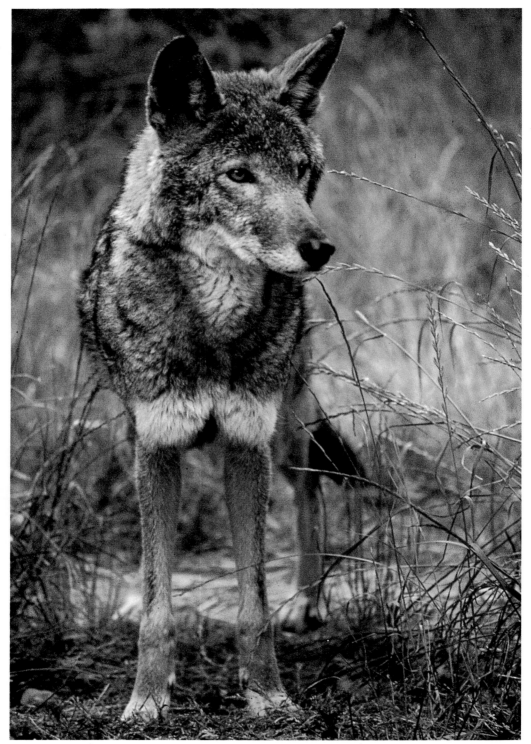

The red wolf gets its name from its reddish hair coat.

here, and that it's a distinct and separate species from the coyote. Others believe the red wolf is a subspecies of the gray wolf and that it looks different from the gray wolf because of environmental and climactic differences between the northern and southern United States. Others say the red wolf is a result of coyotes and gray wolves interbreeding, creating what is known as a "hybrid" species. Still others think that the red wolf is nothing more than a large form of coyote.

If the red wolf is a "large coyote" we would expect it to behave like a coyote. But the red wolf looks and acts more wolflike than coyotelike.

For example, red wolves form packs in the wild—a behavior typical of wolves. Like gray wolf packs, the red wolf packs establish and defend territories and hunt cooperatively for large game like deer and wild hogs. Coyotes, on the other hand, are usually solitary hunters preying mostly on small animals. They only come together to mate and rear their young.

In its final days in the wild, the red wolf *did* interbreed with coyotes, but at this point there's no conclusive evidence that gray wolves and coyotes interbred to create what we now call the red wolf.

We may never know how the red wolf originated, but we do know that before it was almost exterminated, it was the largest canine predator in the

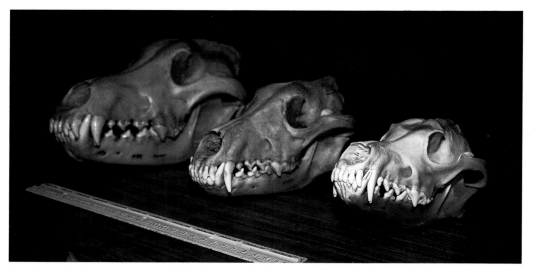

Starting from the left: a gray wolf skull, red wolf skull, and coyote skull. As you can see, the red wolf falls in size between these other wild canids.

southeastern United States. Fossil evidence indicates that it held this role for over 700,000 years.

To understand how the red wolf became so rare we need to take a look at man's persecution of wild canines.

Who's Afraid of the Big Bad Wolf?

When our ancestors arrived here they brought more than their belongings with them. They also brought the mistaken idea that the wolves would kill all the domestic livestock and wild game that settlers depended upon to survive in the wilderness. In addition to this, they also believed that wolves preyed on humans.

Most of their prejudice about wolves came from false information about the nature of wolves. These ideas are still passed down through tales like *The Three Little Pigs, Little Red Riding Hood,* and myths about werewolves. These stories depict wolves as slathering beasts that devour helpless animals and small children.

The truth is that wolves are rarely aggressive toward people. In the United States, there has never been a documented case of a wild wolf killing a human being. In the presence of people, wolves are actually timid and shy. When biologists crawl into wolf dens to look at pups, adult wolves generally run away and come back later when the biologists are gone. A wolf caught in a leg-hold trap is often held down with nothing more than a forked stick or noose on the end of a pole.

Wolves are not bad or evil, they are simply predators attempting to survive in the only way they know how. Like us, they try to get their meat in the easiest and safest way possible. And at times, this means they *will* kill domestic livestock, but this is not as common as many people think.

The War on Wolves

The fear of wolves started a war that eliminated the wolf from most of the United States. Wolves were shot, poisoned, and trapped. In the spring when wolves had their young, the dens were found and the pups slaughtered.

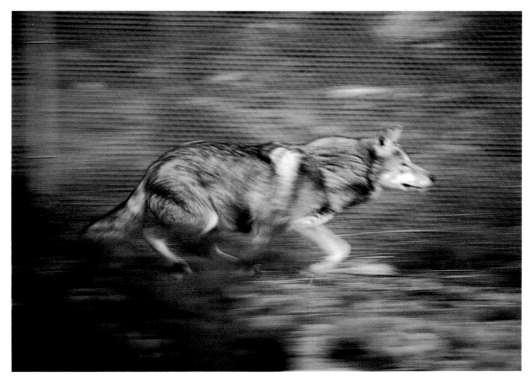
A red wolf can sprint up to twenty-five miles per hour over very short distances.

Every state offered bounties for dead wolves and "wolf bounty hunters" or "wolfers" made their living hunting wolves professionally. Ranchers paid dues into cooperative "wolf clubs." In turn, these clubs paid trappers and hunters to kill wolves. Even the Federal Government participated in the war on wolves. For many years one of the Fish and Wildlife Service's primary responsibilities was "predator control." Instead of studying wolves, Fish and Wildlife biologists were expected to help ranchers and farmers eliminate wolves.

Unfortunately, wolves are easily preyed upon. One reason wolves are so easy to kill is that they form packs and are territorial, meaning that when a wolf pack finds a suitable habitat it generally stays in that area. To eliminate an entire pack all man has to do is to set traps or put out poisoned bait in their territory.

The only red and gray wolves that survived were those that retreated farther into the wilderness. But as soon as man arrived, developing the land

into farms, ranches, and towns, these wolves were eliminated. The few wolves that remained were those that lived on land man didn't want.

The Coyote

The only canine that benefited from this war was the coyote. As wolves were killed, coyotes moved eastward across the country, occupying territories formerly used by wolves.

Unlike the wolf, the coyote thrived in the presence of man despite vigorous efforts to exterminate it. To get a sense of how successful the coyote has been, between 1937 and 1981 over 3.5 million coyotes were killed, yet today coyotes still number in the hundreds of thousands and their population continues to grow.

The coyote's success is due in part to its size, social behavior, and adaptability. Being small, the coyote doesn't need as much food as a wolf. It can live on small animals like rodents, rabbits, and birds, which are more abundant than larger prey like deer, elk, and moose. Because they are solitary and less predictable, coyotes are difficult to locate and trap. These adaptations give the coyote the ability to "make a living" in almost every habitat in the country—including heavily populated cities like Los Angeles, California.

The coyote's success as a species seriously jeopardized the few remaining red wolves left in the wild.

chapter 2

Search and Rescue

East Texas, 1971

A local veterinarian squats near the barn and draws small circles in the dust with a twig he's found. Standing behind him is a biologist from the U.S. Fish and Wildlife Service. Facing both men is the rancher who owns the barn and the land for as far as they can see.

"What we want to do is to have access to your property so we can trap these coyotelike animals that we think are red wolves," the veterinarian explains to the rancher.

"What do you mean wolves?" the rancher asks.

"Not like gray wolves," the veterinarian says. "These are smaller than the grays, but larger than coyotes. They're a different kind of wolf. We're trying to save them."

"Save them from what?"

"From extinction," the biologist answers.

"There aren't many of them left," the veterinarian adds.

"So?"

"So, we think it would be a shame if the last one died."

The rancher laughs. "We've been trying to kill them off for years, and now you're telling me that the government wants to save them?"

"Something like that," the veterinarian says. "But we didn't know we were killing reds. We thought they were all coyotes . . ."

"Grays, reds, coyotes," the rancher interrupts. "What difference does it make, they're all livestock killers. We pay taxes and wolf club dues so trappers will come in here and rid us of the devils. Now you say you want to save them! It doesn't make sense."

"We just want to save a few," the veterinarian says calmly. "We have some captive pens set up for them." He tosses the twig away and stands up, looking directly into the rancher's eyes. "Look at it this way. If you let us trap on your land we're bound to trap some coyotes, and when we do we'll take care of them as well as the reds. What have you got to lose?"

The rancher thinks for a moment. "I guess nothing," he says. "But the government is crazy and so am I for paying taxes for such a foolish plan."

The veterinarian looks at the ground and grins. "Then we can trap here?"

"Yeah, I guess so, but not till tomorrow. I gotta tell the boys you'll be around so they won't shoot you."

"Appreciate it," the veterinarian says and shakes the rancher's hand.

Red Wolf Recovery

In 1973 the U.S. Congress passed the "Endangered Species Act." This law gave federal protection to animals and plants that faced extinction. When a species is listed, a recovery team is formed and prepares a recovery plan that details how to protect habitat and recover the species to the point where it can be taken off the list. The Act provides two classifications for listed animals—threatened and endangered. Threatened species are animals and plants that are likely to become endangered over a significant portion of their range in the near future. Endangered species are animals and plants that are in danger of extinction throughout all or a significant portion of their range. The red wolf was one of the first animals to be listed as an endangered species under the new law.

The primary objectives of the Red Wolf Recovery Plan were to: Certify the genetic purity of wild-caught red wolves; increase the number of genet-

ically pure red wolves in captivity; and maintain a continuing red wolf gene pool for reestablishment of the species in the wild.

By the time the Act became law, biologists concluded that the red wolf had been exterminated in every southeastern state except Texas and Louisiana. The few remaining pockets of red wolves were described as being "surrounded by a sea of coyotes" and the two species were interbreeding. If something wasn't done to stop this, "pure" red wolves would be extinct in a matter of years.

The first step was to find out exactly where and how many red wolves were left in the wild—a task complicated by the fact that coyotes and red wolves were sharing the same territory in some areas.

Wolves and coyotes are very shy. Even biologists who spend all of their time in the field studying canines, rarely get a chance to see one in the wild. They rely instead on finding "canine signs" like pawprints, scats (droppings), and kills. Usually, by studying these signs, biologists can figure out how many canines are in the area, what they are eating, the size of their territory and their patterns of movement. But in the case of the red wolf it was nearly impossible to tell the difference between "hybrid sign" and "red wolf sign" because they were so similar. Biologists had to come up with other ways of finding red wolves. One method they used was howling.

Howling Up Wolves

Why wolves and coyotes howl is still a mystery. Some biologists believe that howling is a warning to other canines that a territory is occupied. Others think that howling is used to attract mates or call members of the pack together. Still others believe that wolves and coyotes howl because they "like the way it sounds and feels." Or as one biologist quipped: "I think that wolves howl just for the 'howl' of it." Whatever the reason, biologists discovered that red wolves and hybrids could sometimes be distinguished by listening to their howls.

There are several ways to make wolves howl. One method is for the biologist to imitate a wolf's howl. One disadvantage of this technique is that it's tough on human vocal cords and "howlers" become hoarse after awhile.

Another method used is to play recorded wolf howls back to the wolves. But perhaps the most reliable way to get wolves to howl is to use a police siren. Something in the sound frequency of a siren causes both wolves and coyotes to howl.

Biologists surveyed all the suspected red wolf areas, using one of the three howling techniques. If canines howled back, the howls were recorded on a special tape recorder, then played into an instrument called a "sonagraph" which translates sound waves into a visual graph. By studying the graph, biologists could often tell whether the howl came from a hybrid or a pure red wolf.

Many of the areas where red wolves were found in Texas and Louisiana were on private land. When biologists found the wolves, they had to get permission from the landowner to use their property. Most of the ranchers and farmers were cooperative once they understood that the biologists wanted to catch the animals.

Trapping Red Wolves

To catch wild canines, biologists used steel leg-hold traps. The traps were set in areas where there were obvious canine signs, or along likely travel routes such as game trails and dirt roads. Traps were sometimes baited with a special foul-smelling "wolf attractant" and they were equipped with "drag chains" so the canine couldn't wander too far away once it was trapped.

To help prevent injuries the traps were fitted with "tranquilizer tabs" and checked at least every twenty-four hours. If the canine tried to get the trap off its paw, it bit into the tranquilizer tab, releasing a drug that helped keep the animal calm until biologists arrived.

Today the use of leg-hold traps is very controversial, but it is still the most effective method for capturing wolves in the wild. It's odd that one of the methods used to exterminate the red wolf was also used to save it from extinction.

From 1974 to 1978 U.S. Fish and Wildlife Service biologists trapped over four hundred canines. After capture, the animal was taken to a central holding facility where it was kept for three to five days so it could recover

A red wolf in a leg-hold trap.

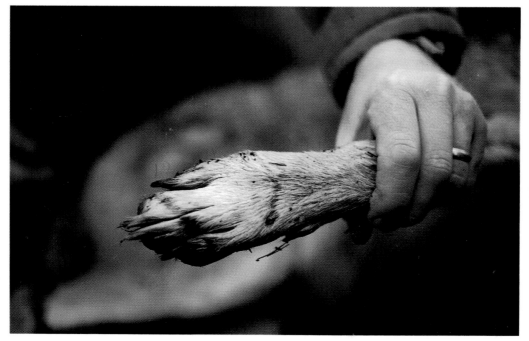

Minor injuries sometimes occur from leg-hold traps, but these generally heal very quickly.

15

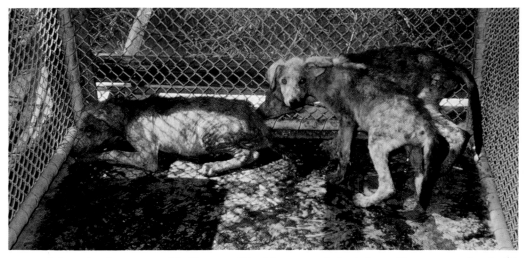

Many of the red wolves captured in Texas and Louisiana were in bad shape. The young wolves in this photo are malnourished and infected with sarcoptic mange. Left in the wild, they would have surely died.

from the effects of the tranquilizer. While there it was weighed, measured, and the skull X-rayed to determine whether it was a coyote, a red wolf, or a hybrid.

Many of the captured canines were in terrible physical condition because of parasites and the harshness of the coastal environment.

The most obvious problem was "sarcoptic mange" caused by a tiny external parasite. Red wolves and coyotes with severe cases of mange were thin and very weak. Some had even rubbed and scratched away most of their hair trying to relieve the itching.

An even more serious problem was that every canine that came into the program was infected with "heartworm." This internal parasite is carried by mosquitoes and injected into the animal as the mosquito is feeding. Adult worms live in the animal's heart and cause severe health problems, which can lead to death.

Last of the Breed

Because of the red wolves' poor physical condition, loss of habitat, hybridization with coyotes, and persecution by man, biologists came to the con-

clusion that the only way to save the red wolf was to take it out of the wild.

Captured animals determined to be hybrids were treated and released. Animals thought to be red wolves were flown to the captive program managed by the Point Defiance Zoo & Aquarium in Tacoma, Washington.

Of the four hundred canines biologists captured, only seventeen were certified as pure red wolves. In only a few decades a magnificent predator that had roamed the southeastern United States for centuries had been reduced to less than twenty animals.

The field program ended in 1980. In the autumn of that same year, genetically pure red wolves were considered extinct in the wild.

chapter 3

Captivity

The Red Wolf Captive Breeding Facility, 1981

A fire engine's siren pierces the night's silence, arousing the red wolves. A few of the wolves pace nervously back and forth along the perimeter of their chain-link enclosures. Others sit very still, their ears forward, gathering in the sound. First one wolf, then another tilts its head back and begins to howl. Soon, dozens of red wolves join in producing a haunting chorus that carries for miles through the cool night.

But not all of the wolves howl . . .

It's whelping season and the female red wolf in pen five answers a different call. She is about to give birth. Inside the concrete den she lays on her side in the fresh straw. Outside, her mate tentatively approaches the den and looks in. The female lifts her head and growls, warning him off. He sprints away and finds a sheltered spot where he curls up to spend the night.

As the last howl echoes through the breeding compound, the first pup is born. The female reaches behind her and bites through the umbilical cord with her sharp incisor teeth, then gently cleans the pup.

The pup squirms and whimpers in response to the cool night air. A few moments later a second pup is born, then a third pup.

An hour later she finishes delivering the litter of pups. One by one she

picks them up from the wriggling pile and gently carries them to the corner of the den where she's hollowed out a nest in the straw. Exhausted, the female curls around the pups to keep them warm. The hungry pups begin to bump their muzzles against her warm fur until they find a teat to suckle.

Just as the sun rises above Mt. Rainier, the red wolf keeper climbs into her truck to check on the wolves and feed them. The compound is less than a quarter mile away and the wolves hear the familiar sound of her truck long before they see it.

The keeper stops at the first pen. Inside are six wolves born the previous year. Two of the young wolves dash back and forth along the fence line. The others are hiding.

She picks up a bucket of dry dog food and after filling the feed pans and replenishing the water, she starts looking for the other wolves. She shines her flashlight in the den and sees three wolves huddled together. This leaves one wolf unaccounted for, but she has a good idea where it's hiding. She walks over to an old log and looks in a shallow hole the wolves have dug. The young wolf sees her and darts from the hole, joining the other two wolves at the fence.

"All healthy," she thinks to herself and heads off to feed and check the wolves in the other pens.

When she gets to the fifth pen she suspects that the female has whelped during the night. Usually, the male and female hide in the den when she goes in to feed, but today they're running around the yard and seem very nervous. She enters the pen and walks toward the den. The female red wolf stops running long enough to give the intruder a couple of uncharacteristic warning barks. The keeper ignores the warning, knowing the female wolf is bluffing. But the barks confirm the keeper's suspicion—she now *knows* the female has whelped during the night and she hopes the pups are okay.

When she gets to the den she crawls through the opening on her hands and knees. Inside she finds a litter of five beautiful red wolf pups squirming over each other and loudly protesting the sudden departure of their warm mother.

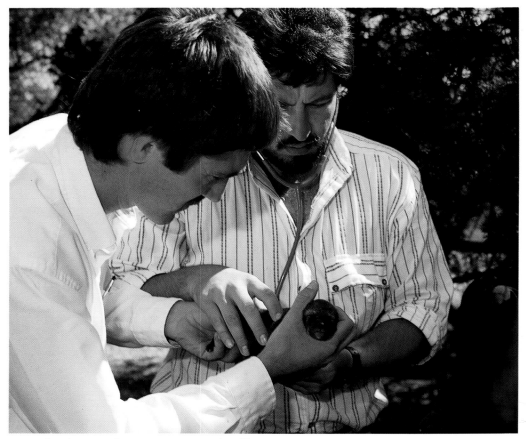

A veterinarian examines a very young red wolf pup.

She picks the pups up one at a time, checking for injuries and noting their sex. Three females, two males. The pups look healthy. The keeper wonders which of these pups, if any, will be released in the wild.

Outside the den, the keeper fills the feed and water pans quickly, not wanting to disturb the new parents. She stops to look at the adult wolves. Three years ago she had crawled into different dens and held these wolves in her hands. Now they had pups of their own. She is pleased. The breeding program was going well, but the red wolves were still a long way from home.

The wolves stare at her from the small stand of Douglas firs. As soon as she drives away the female goes back into the den and checks on her family.

A Long Way from Home

When the Fish and Wildlife Service decided to take the red wolves out of the wild, they contacted several zoos and asked them to help with the captive breeding program. At the time, the only zoo that offered to assist them was the Point Defiance Zoo & Aquarium in Tacoma, Washington. This small northwestern zoo was a long way from Texas and Louisiana, but one advantage it had was that the heartworm parasite wasn't found in Washington State. This meant that the captive wolves had little risk of reinfection. And perhaps even more crucial, their offspring would be born heartworm free.

By the mid-1970s the Point Defiance Zoo had more red wolves than space and there was no land to build additional enclosures. But a member of the Tacoma Zoological Society came to the rescue. He owned a large mink ranch in Graham, Washington, about twenty miles from the zoo and offered to lease five acres of land to the red wolf project for a dollar a year.

The Fish and Wildlife Service and zoo gratefully accepted the offer and built twelve 100' X 100' pens made of heavy gauge chain-link. The pens were six feet tall with three-foot overhangs to prevent the wolves from

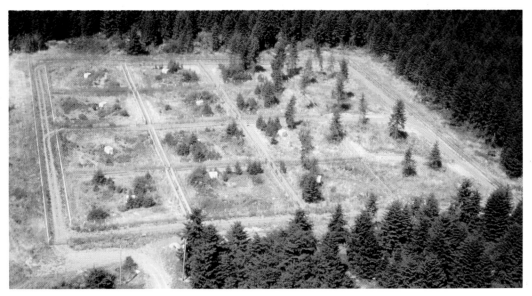

An aerial photograph of the red wolf breeding compound in Graham, Washington.

Straw is put in the den to keep the wolves warm and dry.

escaping over the top. A chain-link "digging barrier" was buried along the inside perimeter of the pens to stop the wolves from tunneling out. Wolf dens were made out of concrete and filled with straw to keep the wolves dry and comfortable.

Handling Red Wolves

In the wild the red wolves' best chance of survival is to stay away from people. Because of this, keepers knew they would have to manage the red wolves differently from other captive animals.

Human contact was kept to a minimum by housing most of the red wolves in "off-exhibit" pens. Only people officially connected with the Red Wolf Recovery Program were allowed access to the wolves. The reason for this limited access was that biologists were afraid that if the wolves got too used to humans they might actually approach people once they were released in the wild—a behavior that can be deadly for a wolf.

If a wolf approaches a hunter there's a chance the hunter might shoot it. If a wolf walks up to an unarmed human, the person might misinterpret the wolf's intentions, thinking that it was going to "attack" them. This mistaken intent could be just as dangerous to the wolf as being shot. The

"rumor" that wolves attack people could spread through the community, turning public sympathy against the wolves. The only way a major predator like a red wolf can be successfully reintroduced is to have the enthusiastic support of the people living near the reintroduction area.

To reinforce the wolf's mistrust of humans, strict guidelines were set regarding how the wolves were to be handled and how keepers were to behave when they were in the pens.

When entering a wolf pen, keepers are encouraged to complete their husbandry duties as quickly and efficiently as possible.

Like dogs, wolves have their own personalities. Some are playful, some are bold, and some are shy. Ideally, when keepers walk into a pen, they like to see the wolves run away or hide. If a wolf approaches a keeper in the pen, whether playfully or aggressively, the wolf is chased away. If the behavior persists other methods might have to be used to discourage the wolf from approaching people. One method is to simply catch the wolf and restrain it for a short period. After being captured and restrained, wolves are less likely to approach people.

Aside from changing undesirable behavior, red wolves are also caught when they're moved to other pens and for medical procedures. The catching technique depends on what the wolf does when handlers go into the pen.

If the wolf is hiding in the den, handlers simply crawl in with it and restrain the animal with a devise called a "catch pole." Once the wolf is "noosed," the keeper uses the pole's leverage to keep the wolf's head on the ground. With the head secured, handlers can carry out minor procedures like giving a shot, drawing blood, or treating wounds.

Surprisingly, when cornered in a secure place like a den, wolves usually lie very still—almost as if they're trying to be invisible. The wolf may snap at the noose a bit, but otherwise offers very little resistance.

The wolf *will* resist, though, if the handler has to take it out of the den. This is because it's being forced to leave its security. As the wolf is pulled outside the den with the catch pole, another handler grabs its hind legs and together the handlers pick the wolf up and gently lower it into a transfer crate. Once the wolf is in the crate, the noose is removed.

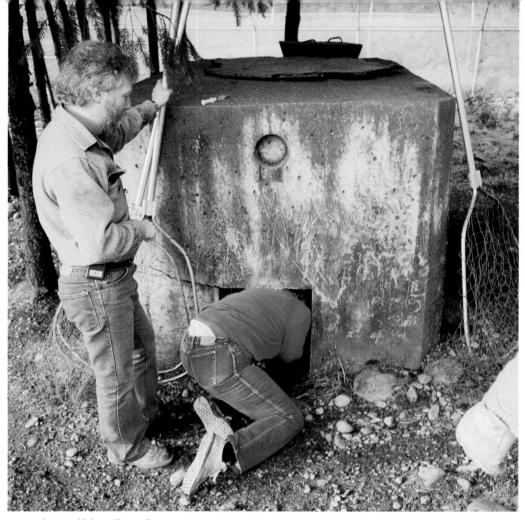

To catch a wolf, handlers often climb into the den with them. Once inside a "noose" is slipped over its neck to restrain it.

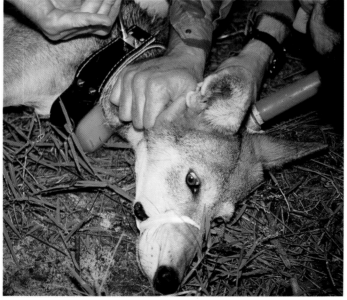

A "restrained" red wolf.

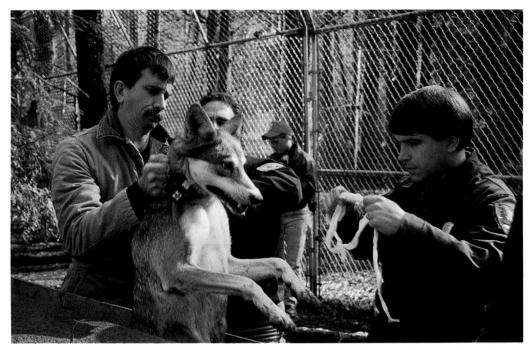

Biologists prepare to "muzzle" a red wolf prior to processing it for release.

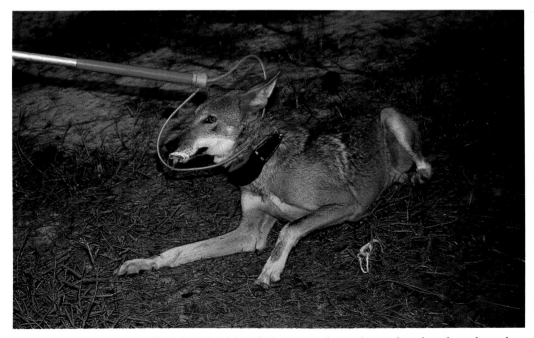

After processing, the red wolf is released. Although these are release photos, they show how the wolves are handled.

25

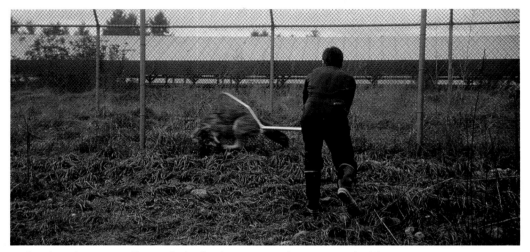

Red wolves that cannot be caught in the den are sometimes captured with nets.

Wolves that run around their pens rather than hide are usually caught with large, long-handled nets. When wolves run, they usually follow the perimeter of the pen. Keepers post themselves near the fence line with their nets ready to catch the wolf as it runs by.

These catching and handling techniques work very well for short procedures. For longer, more complicated procedures like surgeries or physical examinations, the wolves are immobilized with a tranquilizer drug.

Red Wolf Captive Management

If you own a dog, you may be more familiar with how wolves are cared for in captivity than you think. Believe it or not, the dogs we keep in our homes and yards, whether they're tiny poodles or large rottweilers, are actually wolves. Dogs resulted from our domesticating certain wolves over a period of thousands of years. The different varieties of dogs were created by breeding for characteristics such as size or temperament.

In captivity, adult red wolves are paired and kept in large breeding pens. Each wolf is fed two-and-a-half pounds of high-quality dog food a day.

Dog food is fed instead of meat because it is less expensive, easy to store, doesn't go "bad," and provides all the nutritional requirements that a wolf needs to stay healthy.

The daily red wolf husbandry routine is really very simple. The first thing keepers do in the morning is to visually check each wolf to make sure it hasn't sustained an injury since the last time it was seen. After this, the feed and water pans are cleaned and refilled, and the scats are picked up from the yard. Other than checking the wolves a few more times during the day, the wolves are left pretty much on their own.

If a keeper sees a wolf behaving abnormally, or if the animal shows signs of an injury, it's caught, examined, and the problem is treated. If the problem needs daily treatment, the wolf may be put in a small kennel so the keeper can observe and catch the wolf more easily.

Just like your dogs at home, wolves need to be vaccinated every year against rabies, distemper, and other common canine diseases. In addition to this, the wolves are treated monthly for parasitic worms. The worm medication is either given orally in their food, or by injection.

Red Wolf Pups

Unlike dogs, which can breed twice a year, wolves breed only once a year. Female wolves come into heat and mate in late February through March. Pairs are put together a few months prior to breeding season so they can become acquainted.

Female wolves give birth after 60 to 63 days. The average litter size is four or five pups, but they can have as few as one pup and as many as nine. The primary responsibility of rearing the pups belongs to the female. In the wild, the male's parenting role is to bring food to the female and her pups while they're restricted to the den. Of course, in captivity this isn't necessary because keepers provide all the food the wolves need.

At birth, the pups weigh about one pound each and are nearly helpless. For the first two weeks of life their primary activities are sleeping and eating. Then their eyes open and they begin exploring the inside of the den. It's at this time that the pups start to play with each other. Play behavior like stalking, wrestling, and pouncing help the pups develop the physical and social skills they'll need to survive in the wild.

At about six weeks of age the pups begin to venture outside the den

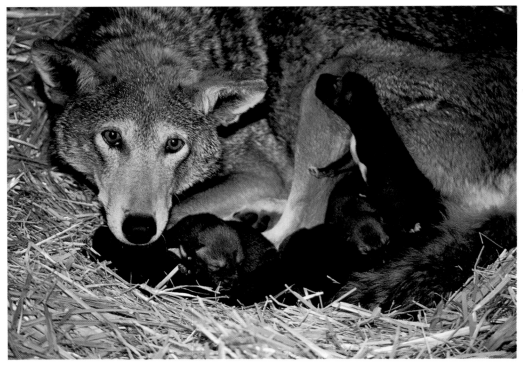

Red wolves give birth once a year. The average litter is five pups, but they can have as few as one pup, and as many as nine pups.

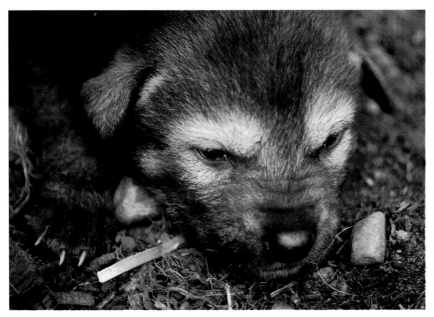

Red wolf pups' eyes open when they are about two weeks old.

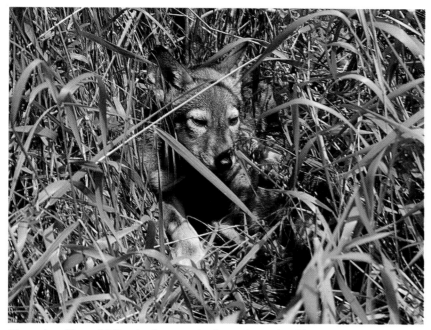

The red wolf pup hiding in the grass is about six weeks old.

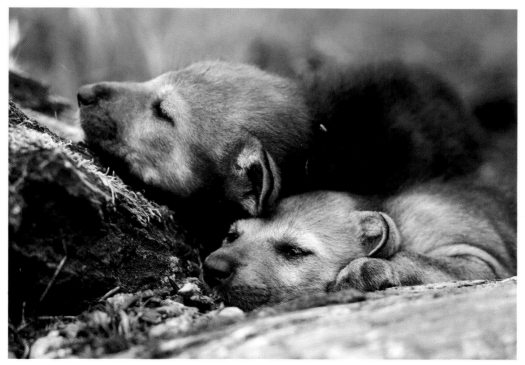

These red wolf pups are about a month old.

29

under the watchful eye of their mother. A whole new world opens up to them—plants, trees, insects, birds, sunshine, wind, and rain. Each day they discover something new, adding to their experience.

When they're three months old the pups weigh about fifteen pounds. Their appearance is rather gangly. They have spindly legs that appear too long for their bodies and ears that seem too big for their heads.

This is the time that their mother begins to wean them from milk. When the pups try to nurse, she rebuffs them or simply walks away. In place of milk, both parents regurgitate semidigested dog food for the pups to eat. The soft food helps the pups make the transition from milk to solid food.

Captive pups usually stay with their parents until the beginning of the next breeding season (usually eight or nine months). They are then moved to a different pen and kept in a group until they become adults.

Wild pups stay with their parents for a longer period, forming what is commonly known as a "wolf pack."

Wolf packs are generally made up of family members of different ages. Youngsters stay with the pack until they are old enough to breed (two to three years). They then leave the pack to seek mates and start families of their own.

Red Wolf Species Survival Plan

In 1983 the red wolf captive breeding program became part of the Species Survival Plan (SSP), which is managed by the American Association of Zoos and Aquariums. This plan is part of a worldwide effort to save threatened and endangered species from extinction.

SSP animals are managed as a group rather than individually by each zoo. In this way, decisions like which animals to breed can be made that will benefit the whole species.

One of the main tools of the Species Survival Plan is the "studbook." Each red wolf in the program is assigned a studbook number. By looking up the animal's number, a keeper can learn whether the animal was captured in the wild or born in captivity, who its parents are, its date of birth, and its current location. With this information keepers decide which animals

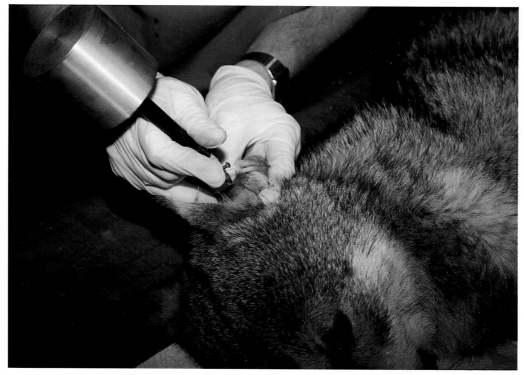

In order to tell one wolf from another, the inside of its ear is tattooed with its studbook number.

should be bred to improve the genetic diversity of the captive population. The studbook numbers are tattooed inside the wolves' ears.

By 1983 the red wolf population had increased to sixty-three animals. But if the red wolf was going to be saved from extinction there would have to be at least five hundred red wolves in captivity and in the wild. In order to reach this goal, zoos from all over the nation were asked to participate in the Red Wolf Species Survival Plan. Dozens of zoos responded by building red wolf pens and joining the effort. Within a few years the captive red wolf population doubled. There were now "surplus" red wolves that could be released into the wild.

Unfortunately, the Fish and Wildlife Service was having difficulties getting permission to release red wolves into areas of their historic range. They were finding that it had been much easier to take wolves out of the wild, than it was to put them back in.

chapter 4

Back Home

Golden Pond, Kentucky, 1983

Representatives of the Fish and Wildlife Service sit at a long table at the front of an auditorium filled with people from the local area, reporters, and environmentalists. The public meeting is the result of two years of hard work by Service biologists. Their goal is to release red wolves into a national recreation area bordering Kentucky and Tennessee called Land Between the Lakes (LBL).

Extensive fieldwork had been done to find out if reintroduced red wolves could survive in LBL. The area was certainly big enough for the wolves to get away from people, and there were a lot of prey animals. The only major obstacle was that coyotes had moved into the area in recent years, and there was a chance the reintroduced wolves might interbreed with them. Other than this, the site seemed ideal and biologists were confident that red wolves would do well at LBL.

But there were still unanswered questions. Would the wildlife departments of Kentucky and Tennessee allow a federally regulated endangered species to be released in their respective states? And, were the majority of local people in favor of the reintroduction?

A spokesman from the Fish and Wildlife Service explains the reintroduction plan. He tells the audience that it will not impact the recreational

use of LBL. Activities like hunting, fishing, hiking, and boating will continue as before. When he's finished he asks if there are any questions or comments.

A man stands up. "First you take our land away," he says loudly. "And now you're going to let wolves loose on us! It isn't right. Why don't you just leave us alone?"

Several people murmur in agreement. The spokesman isn't surprised by this reaction. Not many years before, the Federal Government had come into the area and "bought everyone out" so the Tennessee Valley Authority (TVA) could build the LBL recreation area. Some of the people didn't want to sell their property and move, but they didn't have a choice. Many of them were still bitter about this.

"I understand how you feel," the spokesman says. "I'd feel the same way if I was told to leave my land. But this isn't the red wolf's fault. Having wolves on LBL isn't going to change what happened to you. In fact, the same thing that happened to you happened to the red wolf. People took the wolf's land away. If the wolf stayed on the land it was killed. The red wolf needs and deserves a new home."

Some people nod in agreement, but the majority shake their heads. The spokesman is worried. He has clearly underestimated local opposition.

Several more people stand and ask questions or make comments. Most of them are opposed to the plan, but say they have nothing against the red wolf. Their problem is with the Fish and Wildlife Service telling them what's going to happen on land that used to belong to them.

"The Endangered Species Act supersedes state law," a woman says. "What if the wolves leave LBL and kill my cows?"

"The red wolves released at LBL are expendable," the spokesman says. "We're only releasing surplus wolves. The overall red wolf population will not be impacted by their loss. If a wolf leaves LBL we want the opportunity to recapture it, but if we fail to catch it and the wolf continues to threaten livestock it can be legally killed."

The crowd seems satisfied with this solution. The spokesman breathes a sigh of relief. Perhaps he can sway them after all . . .

Then a man stands up and introduces himself as belonging to an envi-

ronmental group based in Washington, D.C. He tells the officials that he and his group support the red wolf reintroduction at LBL wholeheartedly, but there are two technical aspects that need to be changed.

"The first," he says, "has to do with your plans for coyotes on LBL. You say they are going to be *removed*. I assume by this you mean they are going to be killed?"

"That's correct," the spokesman says, not liking the direction this is going. He realizes now that they should have discussed the reintroduction with environmentalists prior to the meeting.

"I'm afraid that we can't have this," the environmentalist continues. "We believe that the coyotes should be live-trapped and reintroduced elsewhere."

"Where, for instance?"

"Perhaps they could be sent to another location in Kentucky or Tennessee, or sent out of state."

"Coyotes are a problem in every state in the union," the spokesman says evenly. "Nobody's going to want them. And if the coyotes stay at LBL they may interbreed with the red wolves and that will compromise the reintroduction. Besides, it would be impossible to *live-capture* every coyote on LBL. It's unfortunate, but we don't have any alternative but to destroy them."

"Well, we don't want to see them harmed. You're going to have to come up with a better solution."

The spokesman doesn't know what to say to this.

"There's another problem that we feel even more strongly about," the environmentalist continues. "All hunting on LBL must be banned. To have hunters running around with their guns would be too great a risk for the red wolf." He pauses a moment, then adds, "If you don't meet these conditions, we'll go to court and get an injunction."

The man sits down. The audience and officials are stunned. If the environmental group carries out its threat to go to court it could be years before it's resolved.

Soon after, the meeting ends and the officials have a private meeting to discuss the unexpected developments. The game departments tell the Fish and Wildlife Service that they won't support the red wolf reintroduction if

it means that their constituents can't hunt on LBL land. The TVA is also reluctant to go along with the plan. They say their relationship with the local people is already bad enough.

Within five minutes, years of hard work are lost. The plan is rejected as proposed and tabled indefinitely. The bottom line is that red wolves will not be released at LBL.

Alligator River National Wildlife Refuge

Although discouraged by their failure at Land Between the Lakes, biologists did not give up hope of finding a home for the red wolf.

In 1984, 118,000 acres of land in eastern North Carolina was donated to the Fish and Wildlife Service. These lands, which are considered some of the finest wetlands in the mid-Atlantic region soon became the Alligator River National Refuge.

Major habitats in the new refuge included swamps, forests, marshes, and pocosin (thick, almost impenetrable shrubs common to the North Carolina coast). Bear, deer, bobcat, raccoon, mink, gray fox, rabbit, and

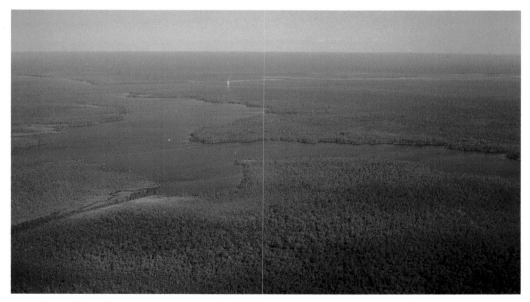

A portion of the Alligator River National Wildlife Refuge in eastern North Carolina.

river otter were found in abundance on the refuge and there were no coyotes. The red wolves would have plenty of cover to hide in and plenty of food to eat. In addition to this, the area was surrounded on three sides by large bodies of water, which would help keep the wolves on the refuge. In many ways it was a better site than Land Between the Lakes.

Aside from getting the project funded by Congress, the first thing the Fish and Wildlife Service had to do was to find out if the local people would support the reintroduction.

The area around the refuge is sparsely populated, with most of the people living in the small communities of Manns Harbor, Stumpy Point, and East Lake.

Public meetings were held in each of these towns, and the overall response to the idea was favorable. Many of the people in the area made their living off the land and were true outdoors people. As such, they were sympathetic to the red wolf's plight and had little objection to having it live near them. The only dissension came from a small group of "houndsmen" who hunted deer with dogs. They were worried that the wolf management plan would put a stop to their activities. The Fish and Wildlife Service didn't like this method of hunting, but said they would allow it to continue as long as it didn't interfere with the reintroduction.

Having learned their lesson at LBL, the Fish and Wildlife Service also met with local and national environmental groups to ask for their support. The groups not only approved the plan, they helped the Fish and Wildlife Service by lobbying Congress for money to pay for the reintroduction.

After obtaining funding and all the necessary approvals, the Fish and Wildlife Service began preparing for the red wolves' arrival. The first step was to hire a team of biologists that had experience in managing wolves in the wild.

The Reintroduction Plan

The only information available about red wolf reintroduction was from an experimental red wolf "translocation" that took place on Bulls Island off the coast of South Carolina. In the mid-'70s a pair of wild red wolves from

Texas were put in a pen on the island for two weeks, then released. The female left the island almost immediately, crossing a treacherous stretch of marsh and water to the mainland. It took biologists several frantic days to capture her. After they had her and her mate back in the pen, they decided to try again. This time though, using a different pair of wolves, they left the animals in the pen for six months, hoping that they'd acclimate to the area and not try to leave when they were rereleased.

The second island reintroduction went much better than the first. The wolves stayed on the island and did well for several months. After the experimental period was over, the wolves were recaptured and sent to the captive breeding facility. The experiment taught biologists the importance of a lengthy acclimation period.

There are two techniques used to reintroduce animals to the wild—the *soft release* and the *hard release*. In a hard release the animal is taken to the reintroduction area in a crate and simply let go. In a soft release the animal

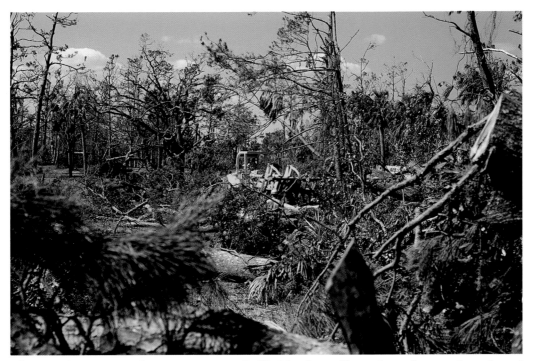

After Hurricane Hugo, almost every tree on Bull's Island was blown down, but somehow the red wolves on the island survived.

Acclimation pens measure 50 x 50 feet and are eight feet tall with a three-foot overhang to prevent the wolves from jumping out.

is put in an acclimation pen at the release site for several days to several months. On the day it is to be reintroduced, the animal is "released" by leaving the gate open. It's free to leave the pen whenever it wants.

The initial reintroduction plan at Alligator River called for "soft" releasing four adult pairs of captive-raised red wolves. The pairs would be put in acclimation pens constructed in remote areas of the refuge. The hope was that when they were freed, the wolves would establish territories near their pens.

The chain-link pens were about half the size of the captive pens and equipped with wooden den boxes for shelter and whelping.

To protect the wolves, the Fish and Wildlife Service decided to house caretakers near each site twenty-four hours a day. Trailer homes were set up at three of the sites and a houseboat at the fourth. The caretakers' responsibilities were to look after the wolves and keep people away from them.

As the pens were being built, the captive managers were deciding which wolves to release. Ideally, to assure reproduction in the wild, they wanted wolves that had already produced litters in captivity. The future of the program depended on pups born and raised in the wild.

In addition, the wolves selected for release had to be surplus to the captive gene pool. This meant that the wolves had to have several brothers and sisters in captivity. In this way, if the wolf died in the wild, the gene pool wouldn't be harmed.

Biologists expected to lose at least half the wolves that were released. The wild is wonderful, but it is also dangerous. The wolves would have to learn to find shelter and kill food on their own. A veterinarian would not be on hand if a wolf became ill or was injured.

On November 12, 1986, four pairs of wolves were flown from the captive facility in Graham, Washington, to Raleigh, North Carolina. In Raleigh they were loaded into a Coast Guard helicopter and taken to the town of Manteo on Roanoke Island.

Hundreds of reporters and local people were at the airport to greet the wolves when they arrived. Biologists were very happy to see this. The more positive publicity the red wolf program got, the better the support would be for the reintroduction.

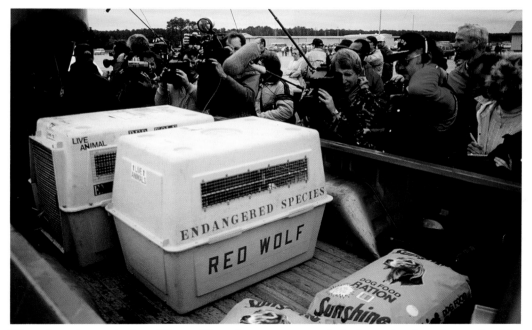

When the wolves arrived at Alligator River, there was a great deal of attention from the people of the area and media from all over the United States.

The wolves were put into trucks and driven to the refuge. Before being released in the pens, each wolf was fitted with a temporary radio collar. This not only got the wolves used to wearing collars, it also provided a way for biologists to track a wolf in case it accidentally escaped.

A new type of radio collar was to be used on the wolves when they were released. Not only were biologists supposed to be able to track the wolves with the new collar, it was also supposed to be capable of tranquilizing a wolf from several miles away. The "capture collar" was equipped with special tranquilizer syringes that could be activated by a radio signal.

Preparing for the Wild

During their first two months in the acclimation pens the wolves were fed their regular diet of dry dog food. After this, caretakers began offering them

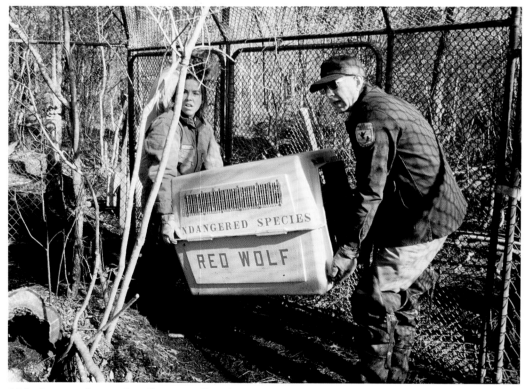

Biologists transfer a red wolf to an acclimation pen.

During the first part of their acclimation period, the red wolves were fed dry dog food.

deer, opossum, raccoon, nutria, squirrel, and rabbit—foods they would feed on in the wild. Many of the animals fed to the wolves were "road kills" brought in by state game officials. Other prey animals were donated by hunters and trappers who wanted to help the red wolves.

Initially there was some concern over the captive wolves' ability to kill live animals. Biologists knew that without this skill the wolves wouldn't stand a chance in the wild. To remove this doubt, a few live animals were put in the pens. Much to everyone's relief, the wolves killed the animals quickly and efficiently.

41

After the wolves were switched to a meat diet, caretakers began feeding them every other day and eventually every four days, to get them used to the concept of "feast or famine." Unlike captive wolves that are provided food every day, wild wolves usually gorge themselves with large quantities of food and then go a few days without eating.

The reintroduction was scheduled for early May, 1987, when the populations of rodents, rabbits, and deer would be at their peak. This was also the time of year that prey animals had their young. Biologists believed that the young animals would be just as inexperienced as the wolves and therefore easier prey than adult animals.

Unfortunately, the release plans were delayed several times because of malfunctions in the new capture collars.

The first problem was that the signal couldn't be picked up more than a half mile away. After this problem was fixed, technicians found that the tranquilizer darts wouldn't fire.

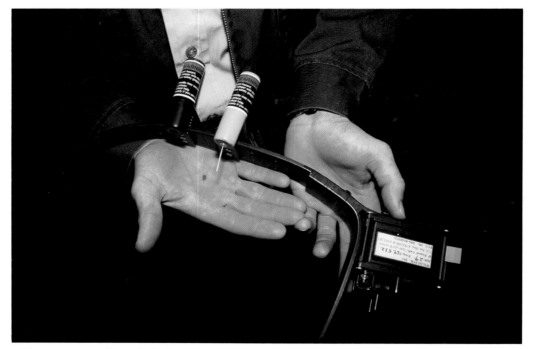

With a "capture collar," biologists can tranquilize the wolf remotely from a distance. The tranquilizer dart is fired using radio signals.

Each time a new problem was discovered, the collars had to be sent back to the manufacturer. May and June passed and in July the collar was tried again, but it still didn't work.

Biologists wanted to use a conventional radio collar on the wolves rather than the capture collar, but they couldn't. During the public meetings the Fish and Wildlife Service had "promised" the people that the capture collar would be used, at least during the first stage of the reintroduction. And there were some who said that the reason the reintroduction had been approved in the first place was *because* of the capture collar.

Finally, in September two collars arrived that seemed to be working, but by this time, biologists had very little faith in them. If they couldn't track the wolves, how could they manage them?

It was finally decided to put two radio collars on the wolves—the new collar and a conventional radio collar. In this way, if the capture collar failed, the biologists would still be able to track the wolves. Once the collars were tested under field conditions, the wolves would be recaptured and one of the collars removed.

chapter 5

Freedom

Alligator River, 1987

The red wolves hear the truck coming up the road from a half mile away. It stops a short distance from the pen and soon two biologists enter the pen. They drop deer haunches near the dens, check the water, watch the wolves for a moment, then leave.

But something's different this time. The wolves stare at the gate to the pen. It has been left open.

The open gate makes the wolves nervous. Instead of running over to the deer meat as usual, the wolves continue to look at the gate, expecting the biologists to come back inside, but they don't. The wolves hear the doors to the truck and the roar of the engine as it drives away.

The biologists stop about two miles from the pen.

"Let's check them."

They assemble a hand-held antenna, attach the cable to the receiver, and dial in the male's radio-collar frequency. The biologist points the antenna toward the pen and hears a steady *beep . . . beep . . . beep . . .*

"The male's coming in loud and clear," he says. "I'll try the female." He dials in her number and nods. "As far as I can tell they're both in the pen. We'll check again in a little while."

The female slinks toward the open gate. When she reaches it she stops—

listening and watching for danger. She sniffs the air, then sees that a deer carcass has been placed about twenty feet outside the pen.

The male joins her at the opening. They stare at the carcass, wondering what this change means.

The biologists take radio locations on the wolves throughout the day. At dusk two other biologists pull up in a truck to take over the next tracking shift.

"Any activity?"

"As far as we know they're still at the pen."

"Good. Maybe the carcass will hold them there for a few days until they get oriented. We'll give you a call if anything happens."

With great caution the female steps through the opening and stands very still just outside the pen. She doesn't realize that she has just stepped into the wild.

The Invisible Fence

In a sense, when the red wolves were released at Alligator River, the refuge would become like a very large pen. The wolves were free, but not entirely free. There wasn't a fence, but there were legal and political boundaries—a barrier the wolves could not see. It was the biologists' job to keep the wolves within this invisible fence.

Biologists would have to use two primary skills to help them with this task—radio tracking and trapping.

Radio Tracking

Because the wolves are rarely seen, one of the few ways biologists have to monitor their activities is to radio track them.

Radio tracking (also known as radiotelemetry) has been used for many years to study wildlife. The collars used on wolves weigh a little over a pound. The main components are a battery and a transmitter that emits a signal on a specified frequency.

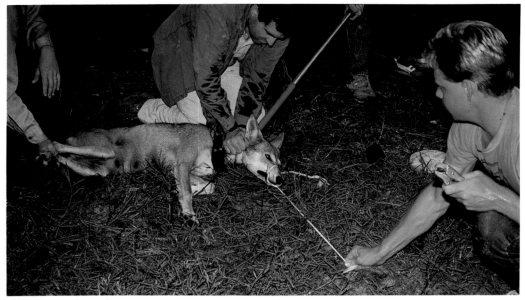

After the radio collar is attached, the muzzle is pulled off and the wolf is released.

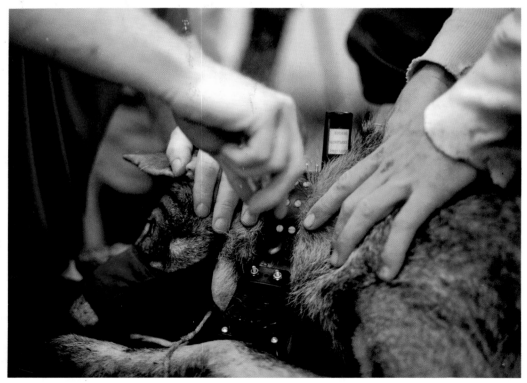

A red wolf is fitted with an experimental "capture collar."

To pick up this signal, biologists use a special receiver and an antenna. When the correct frequency is dialed in and the antenna is pointed toward the wolf, trackers hear a steady beeping signal—the closer to the wolf, the stronger the signal.

Some radio collars have the ability to emit different types of signals, depending on what the wolf is doing. For instance, if the wolf is active, the beeps become more rapid. There are collars that even have a "mortality mode"—one signal biologists never want to hear. It only comes on when the collar hasn't moved for several hours, which means the wolf has likely died.

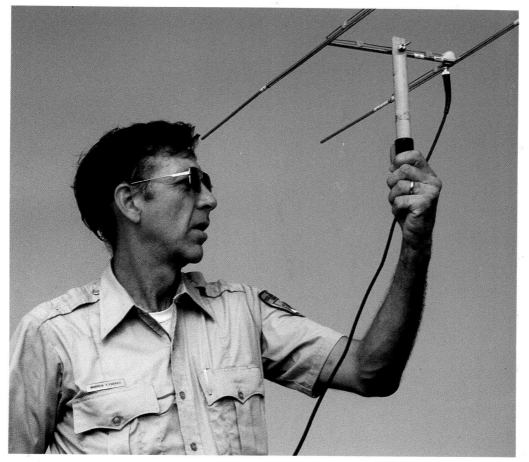

By moving the antenna attached to the receiver and listening to the strength of the signal from the collar, biologists can determine where the red wolf is.

To locate a wolf, the biologist stands with the antenna above his head and slowly turns it in a circle until he hears the signal. The direction the signal is coming from is marked on a map. The biologist then moves to another location (usually a mile or so away) and gets a second bearing on the wolf. The wolf's location is approximately where the bearings intersect on a map.

Ground tracking can be very difficult and is often very inaccurate. Signals can be interrupted by hills, trees, and weather. Another disadvantage is that the tracker has to be relatively close to the wolf to pick up the signal—usually within a mile.

A much more reliable system of radio tracking (also more expensive) is to track by air. The antennas are attached outside the airplane and the biologist sits next to the pilot and listens for the signal on a headset attached to the receiver.

Tracking by air has many advantages over ground tracking: Signal interference is much less because you are above the hills and trees; on a clear day, the signal can be picked up from as far away as ten miles; locations are more accurate because you can fly right over the top of the wolf and pinpoint where it is.

Trapping Wolves

Biologists knew that reintroduced wolves would have to be recaptured for a variety of reasons. Collar batteries would need replacing. Young wolves would have to be trapped and radio-collared. And, of course, wolves that wandered outside the refuge would have to be recaptured.

As noted earlier, the most effective method for catching wild wolves is to use leg-hold traps. At Alligator River they decided to use a small leg-hold trap called a "soft catch." The jaws on this trap are padded with rubber, which is supposed to reduce the risk of injury.

Leg-hold traps are set just beneath the ground and baited with a wolf attractant. Because the wolves at Alligator River would be collared, biologists would be able to set the traps in areas they *knew* the wolves were frequenting.

Traps would be checked often and sometimes monitored twenty-four hours a day so they could get the wolf out of the trap as soon as it was caught. One method of monitoring a trap from a distance is to attach a transmitter to it. When the trap is moved the transmitter goes off, alerting biologists that a wolf may have been caught.

Freedom

On September 13, 1987, the first pair of red wolves was processed for release. This included fitting the wolves with new radio collars, administering worm medication, giving them their final vaccinations, and weighing them.

The following morning biologists fed the wolves as usual, but didn't close the door behind them.

The wolves were radio-monitored from a boat approximately one mile away from the pen. Project biologists were happy that the red wolves would

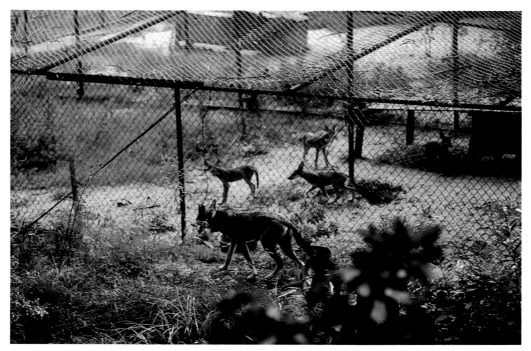

A male red wolf looks at his family still wary about leaving the acclimation pen on Bull's Island.

Reintroduced red wolves in an agricultural field at Alligator River National Wildlife Refuge.

finally be free, but they were also worried. Would the captive-born wolves learn to hunt for food? Would they stay on the refuge?

Up to this point, the red wolves' future had been up to a handful of dedicated people. When the wolves stepped outside the pen, their future would be up to them.

The wolves remained near or in their pen for thirty hours. At 3:00 A.M., on the morning of the 16th, an unusual amount of activity was noted and the radio signals indicated the wolves were on the move.

It had been over a hundred years since red wolves had run free on North Carolina soil.

Born to be Wild

Within a few weeks the rest of the red wolves were set free.

Typically the wolves stayed near their pens for several days, then started to wander around the refuge. Sometimes the pairs traveled together and sometimes they split up and went in opposite directions. When the wolves moved to new areas, biologists put out some food so they would have something to eat while learning how to hunt.

The first few weeks was a wild time for biologists as well as for the wolves. They had trouble keeping track of all the animals, despite the fact

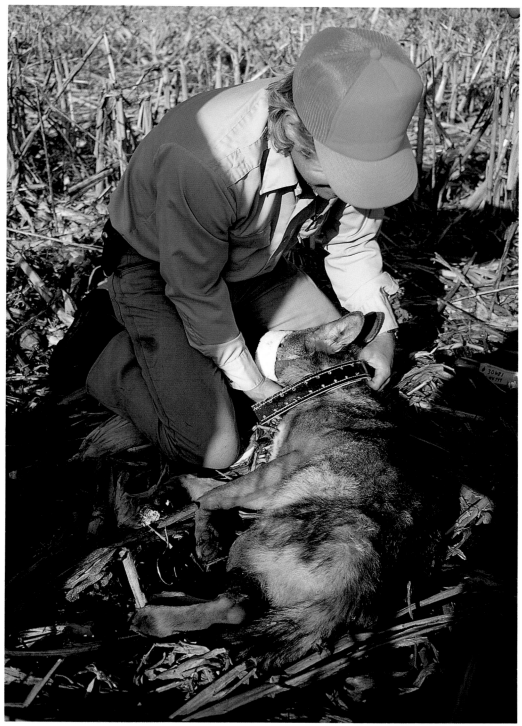

Biologist places a collar on a wild-born pup at Alligator River.

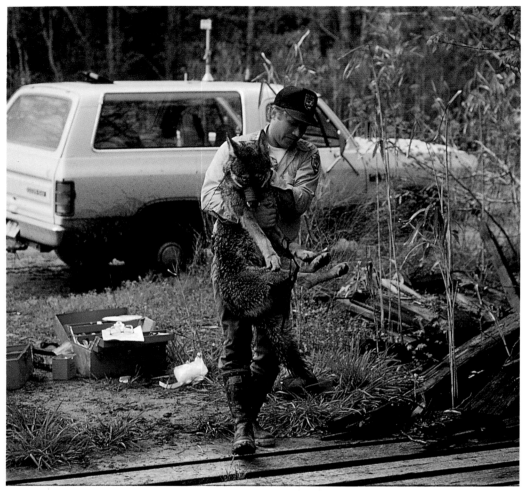

Biologist prepares to rerelease a wild-born red wolf after putting a radio collar on it.

that they were monitoring the wolves twenty-four hours a day, seven days a week.

Initially, some of the wolves seemed disoriented and confused. They'd wander around the refuge until they found a dirt road, then they'd follow it with no apparent destination in mind. Unfortunately, the refuge roads eventually led to major highways and the wolves were often found trotting along the shoulders, or even worse, right down the middle of highways! On several occasions, biologists had to stop traffic while they tried to haze a wolf off the highway back into the refuge. The biologists weren't able to be

everywhere at once and this resulted in a couple of wolves being hit by cars and killed.

One of the wolves left the refuge and ended up in the town of Manns Harbor. Biologists chased the wolf for half the night through people's backyards. They were eventually able to corner it and shoot it with a tranquilizer dart. It was taken back to the refuge and rereleased a few weeks later.

A few months after the first release, the capture collars began to fail. This meant that all the wolves wearing the new collar had to be trapped so the collar could be removed. Fortunately, biologists had proven to the local people that they could trap wolves without the capture collar and they were able to use the more reliable, conventional radio collars.

Despite these problems, the reintroduction was going better than many people expected. Eventually the red wolves began to adjust to their new life in the wild. They learned to hunt, established territories, and found mates.

Much to everyone's surprise, two females produced litters their first year out. This was a sure sign that the wolves were adjusting to life in the wild.

In January of 1988 more captive red wolves were taken to Alligator River. Some of these animals were released later that summer.

By the end of 1994 there were nearly fifty red wolves running on the refuge. Thirty-seven of these were wild born.

The red wolf was back home!

Alligator River—Today

Two fishermen sit in a small boat as it slowly makes its way down a narrow channel of water. The moon is nearly full, illuminating the billowy ground fog in front of them. One of the men looks over the bow for logs and other debris.

"I can't see a thing in this fog," he says to his partner who's in the stern operating the motor.

"Doesn't matter," the other man shouts above the engine noise. "If we hit something at this speed it won't hurt anything anyway. Come on back here and pour me a cup of coffee."

The man at the bow pulls a small flashlight from his pocket and finds the thermos. He pours a cup of steaming coffee for his partner.

"How long before sunrise?" he asks.

"Half hour, maybe longer. We should be at Alligator River before then."

"Not a breath of wind this morning."

"Nope. Sure hope we catch something today."

"Me too . . . wait a second." The man turns his head to the side, listening.

"What?"

"Did you hear that?"

"I didn't hear anything," the man in the stern says impatiently.

"Turn the engine off."

He turns it off and the boat drifts silently down the channel.

"Are you sure . . ."

"Shhhhh . . . there . . ."

A wolf begins to howl and is soon joined by others. Their call is answered by another pack several miles away.

"Red wolves!"

"Yeah."

"Beautiful."

The two men listen long after the final howl is sung, hoping for more.

"You know," one of men says. "I don't care if we catch anything or not."

The other man smiles. "I know what you mean."

Afterword

The red wolf's journey could have ended in many ways. The last wolf could have been shot or trapped, or died of parasite infestation in the coastal marshes of Texas and Louisiana. The journey could have ended with a handful of red wolves in captivity. But instead, their journey continues.

After the success at Alligator River several other red wolf reintroductions were started in the Southeast.

Red wolves were put on Horn Island off the coast of Mississippi, on Bulls Island off the coast of South Carolina, and on St. Vincent's Island off the coast of Florida. The pups born on the islands were taken to Alligator River and released.

In 1991 a second mainland reintroduction was started in the Great Smoky Mountains National Park located on the borders of North Carolina and Tennessee.

The red wolf has traveled far in a few short years, from the brink of extinction with only seventeen wolves left, to a population of nearly three hundred wolves—many of them running free in their historic range.

There will never be as many red wolves as there once were, but it's good to know that we still have a place in our hearts that longs to hear the howls of wild wolves.

Where to See Red Wolves

The best way to see a red wolf is to visit one of the many zoos that have set up a breeding program for them. You might want to call the zoo first to make sure that the wolves are on exhibit.

If your local zoo isn't listed below, check to see if they've gotten red wolves since the publication of this book. Every year more and more zoos are joining the fight to save this rare and beautiful animal.

Alexandria Zoological Park, Alexandria, Louisiana
Audubon Zoological Gardens, New Orleans, Louisiana
Beardsley Zoological Garden, Bridgeport, Connecticut
Burnet Park Zoo, Syracuse, New York
Chaffee Zoological Gardens, Fresno, California
Fort Worth Zoological Park, Fort Worth, Texas
Fossil Rim Wildlife Center, Glen Rose, Texas
Greater Baton Rouge Zoo, Baker, Louisiana
Great Plains Zoo, Sioux Falls, South Dakota
Henson Robinson Zoo, Springfield, Illinois
Knoxville Zoological Gardens, Knoxville, Tennessee
Land Between the Lakes, Golden Pond, Kentucky
Los Angeles Zoo, Los Angeles, California
Lowry Park Zoological Garden, Tampa, Florida

Mill Mountain Zoo, Roanoke, Virginia
Miller Park Zoo, Bloomington, Illinois
National Zoological Park, Washington, D.C.
North Carolina Life & Science Museum, Durham, North Carolina
Oglebay's Good Children's Zoo, Wheeling, West Virginia
Pittsburgh Zoo, Pittsburgh, Pennsylvania
Point Defiance Zoo & Aquarium, Tacoma, Washington
Roger Williams Park Zoo, Providence, Rhode Island
Ross Park Zoo, Binghamton, New York
Tallahassee Junior Museum, Tallahassee, Florida
The Texas Zoo, Victoria, Texas
Trevor Zoo, Millbrook, New York
Western North Carolina Nature Center, Asheville, North Carolina
Wild Canid Survival & Research Center, Eureka, Missouri
The Wilds, Zanesville, Ohio

Index